Egon Schiele

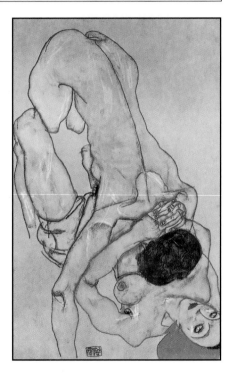

Jeanette Zwingenberger

Publishing director: Jean-Paul Manzo

Publishing associate: Cornélia Sontag

Editor: Amélie Marty

Text: Jeanette Zwingenberger

Design: Cédric Pontes

ISBN 1 85995 720 X

Introduction

In 1964, Oskar Kokoschka evaluated the first great Schiele
Exhibition in London as "pornographic". In the age of discovery
of modern art and loss of 'subject', Schiele responded that for him
there exists no modernity, only the "eternal". Schiele's world
shrank into portraits of the body, locally and temporally non-
committal. Self-discovery becomes an unrelenting revelation of
himself as well as of his models. The German art encyclopedia,
Thieme and Becker, qualifies Schiele as an eroticist because Schiele's
art represents the erotic portrayal of the human body. In this case,
however, it is for him not only a study of feminine, but also male
nudity. His models characterize an incredible freedom with
respect to their own sexuality, self-love, homosexuality or voyeu-
ristic attitudes, as well as skillful seduction of the viewer. Clichés
and criteria with regard to feminine beauty, perfect smoothness
and sculpture-like coolness, however, do not interest him. He
knows that the urge to look is interconnected with the mecha-
nisms of disgust and allure. It is the body which contains the
power of sex and death within itself.

The photograph, *Schiele on his Deathbed* (1), depicts the twenty-eight year old nearly asleep, the gaunt body completely emaciated, head resting on his bent arm; the similarity to his drawings is astounding. Because of the high danger of infection, the last visitors were able to communicate with the Spanish flu-infected Schiele only by way of a mirror – in which he viewed himself and his models – which was set up on the threshold between his room and the parlor. During the same year, 1918, Schiele had designed a mausoleum for himself and his wife. Did he know, he who had so often distinguished himself as a person of sight, of his sudden end? Does individual fate fuse collectively with the fall of an old system here, that of the Hapsburg Empire?

Schiele's productive life scarcely extends beyond ten years, yet during this time he produced 334 oil paintings and 2,503 drawings (Jane Kallir, New York, 1990). He painted portraits and still-life-like land and townscapes; however, he became famous as a draftsman. While Sigmund Freud exposes the repressed pleasure principles of upper-class Viennese society, which puts its women into corsets and bulging gowns and grants them solely a role as future mothers, Schiele bares his models. His nude studies penetrate brutally into the privacy of his models and finally confront the viewer with his own sexuality.

Schiele's Childhood

Under the sign of modern industrial times, with the noise of racing steam engines in factories and the human masses working there, Egon Schiele is born in the railway station hall of Tulln, a small, lower Austrian town on the Danube on June 12, 1890. After his older sisters Melanie (1886–1974) and Elvira (1883–1893), he is the third child of the railway director

4

1. *Schiele on his Deathbed*, 1918

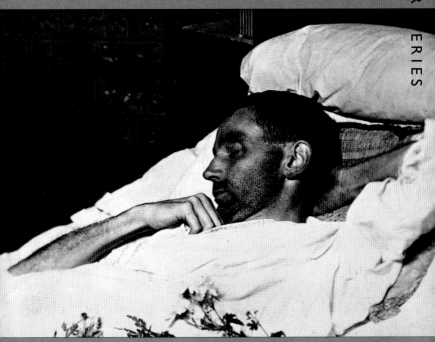

Adolf Eugen (1850–1905) and his wife Marie, née Soukoup (1862–1935). The shadows of three male stillbirths are a precursor for the only boy, who in his third year of life will lose his ten-year-old sister Elvira. The large infant mortality rate was the lot of former times, a fate which Schiele's later work and his picture of woman will characterize. In 1900, he attends the grammar school in Krems. But he is a poor pupil, who constantly takes refuge in his drawings, which his enraged father burns. In 1902, he sends his son to the regional grammar and upper secondary school in Klosterneuburg. The young Schiele has a difficult childhood marked by the illness of his father, who suffers from syphilis, which, according to family chronicles, he is said to have contracted while on his honeymoon as a result from a visit to a bordello in Triest. His wife fled from the bedroom during the wedding night and the marriage was only consummated on the fourth day, on which he infected her also.

5

Despair characterizes Schiele's father, who, retired early, sits at home dressed in his service uniform in a state of mental confusion. In the summer of 1904, stricken by increasing paralysis, he tries to throw himself out of the window. Finally, he dies after grave suffering on New Year's Day 1905. The father, who during a fit of insanity burned all railroad stocks, leaves his wife and children destitute. The uncle, Leopold Czihaczek, chief inspector of the imperial and royal railway, assumes joint custody of the fifteen-year-old Egon, for whom he foresees the traditional family role of railroad man. During this time, young Schiele wears the second-hand clothing of his uncle and fashions stiff white collars made from paper. It seemed that Schiele had been very close to his father for he, too, had possessed a certain talent for drawing, had collected butterflies and minerals and was very close to nature.

Years later, Schiele writes to his sister: "I have, in fact, experienced a beautiful spiritual occurrence today, I was awake, yet spellbound by a ghost who presented himself to me in a dream before waking, so long as he spoke with me, I was rigid and speechless." Unable to accept the death of his father, Schiele lets him rise again in visions. He reports that his father had been with him and spoken much to him. In contrast, distance and misunderstanding characterize his relationship with his mother who, living in dire financial straits, expects her son to support her; in return, the older sister would work for the railroad. However, Schiele, who had been pampered by women during childhood, claims that "he is an eternal child".

A wink of fate is the painter Karl Ludwig Strauch (1875–1959), who instructs the gifted youth in draftsmanship; the artist Max Kahrer of Klosterneuburg looks after the boy as well. In 1906, at the age of only sixteen, Schiele passes the entrance examination of the general art class at the Academy of Visual Arts in Vienna on first attempt. Even the strict uncle, in whose household Schiele now takes his daily midday meal, sends a telegram to Schiele's mother: "Passed".

2. *Nude Girl with Folded Arms* (Gertrude Schiele), 1910
Watercolor and black crayon, 48,8 x 28 cm
Graphische Sammlung Albertina, Vienna

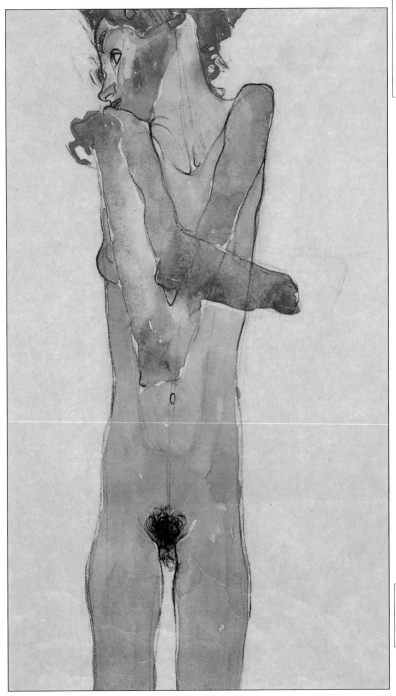

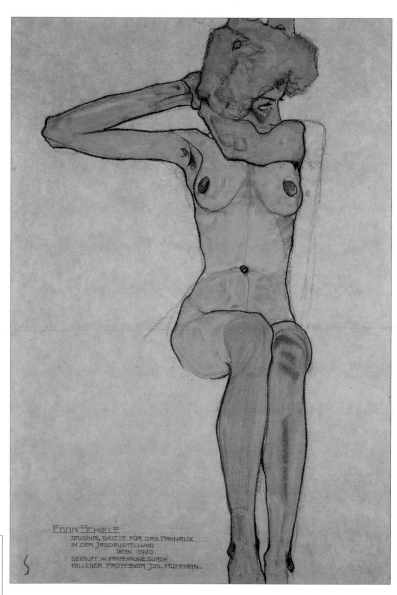

EGON SCHIELE
ORIGINAL SKIZZE FÜR DAS PANNAUX
IN DER JAGDAUSTELLUNG
WIEN 1910
GEKAUFT IM KAFFEHAUSE DURCH
KOLLEGEN PROFESSOR JOS. HOFFMAN.

The Favorite Sister, Gerti

The nude study of the fiery redhead with the small belly, the fleshy bosom and the tousled pubic hair is his younger sister Gertrude (1894–1981) (2,3). In another watercolor, Gerti reclines backwards, still fully clothed with black stockings and shoes, and lifts the black hem of her dress from under which the red orifice of her body gapes. Schiele draws no bed, no chair, only the provocative gesture of his sister's body offering itself (4). Incestuous fantasies? The sister, four years his junior, is a compliant test object for him.

3. *Seated Female Nude with Raised Right Arm*, 1910
Watercolor and black crayon,
45 x 31,5 cm
Historisches Museum
der Stadt Wien, Vienna

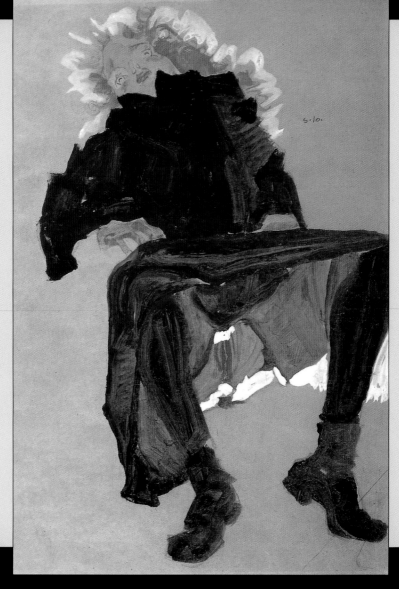

4. *Reclining Girl in Dark Blue Dress*, 1910
Gouache, watercolor and pencil with white highlighting, 45 x 31,3 cm
Private collection, courtesy of Gallery St. Etienne, New York

The point in time during which Sigmund Freud discovers that self-discovery occurs by way of erotic experiences, and the urge to look emerges as a spontaneous sexual expression within the child, young Egon records confrontation with the opposite sex on paper. He incorporates erotic games of discovery and a lively interest in the genitalia of his playmate into his nude studies. The forbidden gaze, searching for the opened female sheath beneath the rustling of the skirt hem and white lace. Gerti with her freckled skin, the green eyes and red hair is the prototype of all later women and models of Schiele (5).

5. *The Scornful Woman* (Gertrude Schiele), 1910
Gouache, watercolor and black crayon
with white highlighting, 45 x 31,4 cm
Private collection

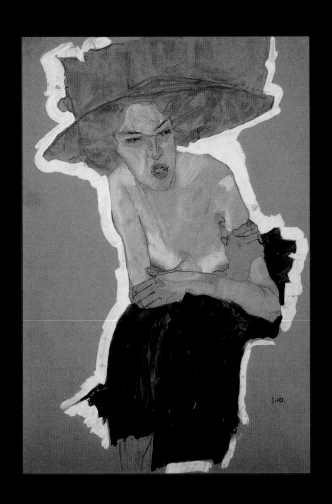

Vienna at the Turn of the Century

Vienna is the capital city of the Danube monarchy, a state of multiple ethnicities consisting of twelve various nations with a population of approximately thirty million. Emperor Franz Josef maintains strict Spanish court etiquette. Yet, on the government's fortieth anniversary, he begins a large-scale conversion of the city with its approximately 850 public and private monumental structures and buildings.

At this time, the influx of the rural population selling itself to the big city increases. Simultaneously, increasing industrialization results in the emergence of the proletariat in the suburbs, while the newly rich bourgeoisie settle in the exclusive Ring Street. In the writers' cafés, Leo Trotski, Lenin and later on Hitler consult periodicals on display and brood over the beginning century.

Just how musty the artistic climate in Vienna was is evidenced in 1893 by the scandal over Engelhard's picture *Young Girl under a Cherry Tree*, which was repudiated on grounds of "respect for the genteel female audience, which one did not wish to embarrass so painfully vis-à-vis such an open-hearted naturalistic study". What mendacity, where official exhibitions of nude studies, the obligation of every artist, had long been an institution.

In 1897, Klimt together with his Viennese fellow artists founded the *Vienna Secession*, a splinter group separated from the officially accepted conduct for artists under the motto: "To the times its art, to the art its freedom".

In 1898, the first exhibition takes place in the building of the horticultural society. It is distinguished from the usual mass exhibitions of several thousand works in the sense that it offers an elite selection of 100 to 200 works of art. The proceeds generated by the attendance of the approximately 100,000 visitors finance the future exhibition building of the architect Olbrich. Exhibitions of Rodin, Kollwitz, Hodler, Manet, Monet, Renoir, Cézanne and van Gogh open the doors to the most up-to-date international art world. Visual artists work beside renowned writers and musicians such as Rilke, Schnitzler, Alternberg, Schönberg and Alban Berg for the periodical *Ver Sacrum*. Here they develop the idea of the complete work of art, which encompasses all artistic areas. Simultaneously, the *Secession* requires abolition of the distinction between higher and lower art, art for the rich and art for the poor and declares art common property. Yet, this demand of the art nouveau generation remains a privilege of the upper class striving for the ideal that "art is a life style", which encompasses architectural style, interior, clothing and jewelry.

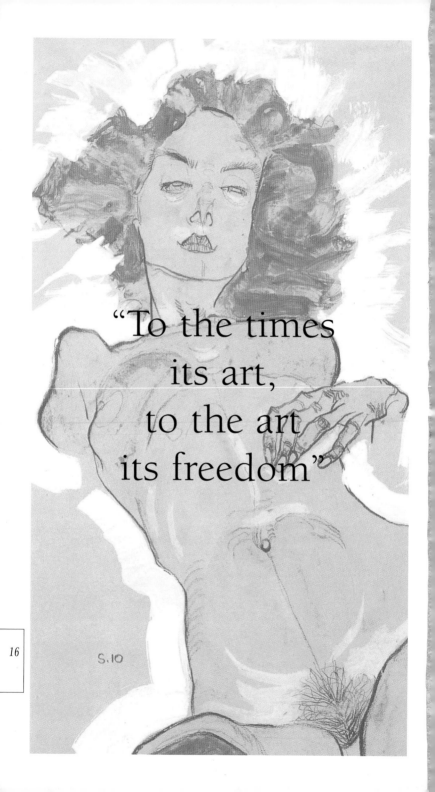

"To the times
its art,
to the art
its freedom"

Gustav Klimt, the Father Figure

In 1907, Schiele makes the acquaintance of Gustav Klimt (1862–1918), who becomes his father figure and generously supports the talent of the young genius for the rest of his life. They exchange drawings with one another and Klimt even models for Schiele. In his career, Klimt profits from the large volume of commissioned work, such as the 24-meter-long *Beethovenfries* created for the faculty. Nevertheless, he runs into misunderstanding with the central motif of the embrace, a nude couple, with his contemporaries. Criticism against Klimt becomes more vehement with regard to his drawings for the simultaneously founded periodical *Ver Sacrum*, which was confiscated by a public prosecutor because "...the depiction of the nude grossly violated modesty and, therefore, offended the public". Klimt answered that he wanted nothing to do with stubborn people. What was decisive for him was who it was to please. For Klimt, who was supported by private patronage, this meant his clientele of Viennese middle-class patrons.

Schiele's Models

Contrary to Klimt, Schiele finds his models on the streets, young girls of the proletariat and prostitutes; he prefers the child-woman androgynous types. The thin, gaunt bodies of his models characterize lower-class status, while full-bosomed, luscious ladies of the bourgeoisie express theirs through well-fed corpulence. Yet, the attitude of the legendary empress Sissi is symptomatic for a time, in which the conventional picture of woman begins to sway.

6. *Female Nude*, 1910
Gouache, watercolor and black crayon
with white highlighting, 44,3 x 30,6 cm,
Graphische Sammlung Albertina, Vienna

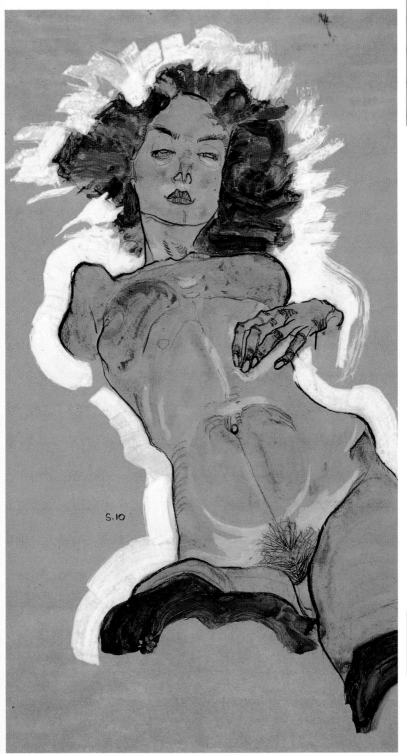

S.10

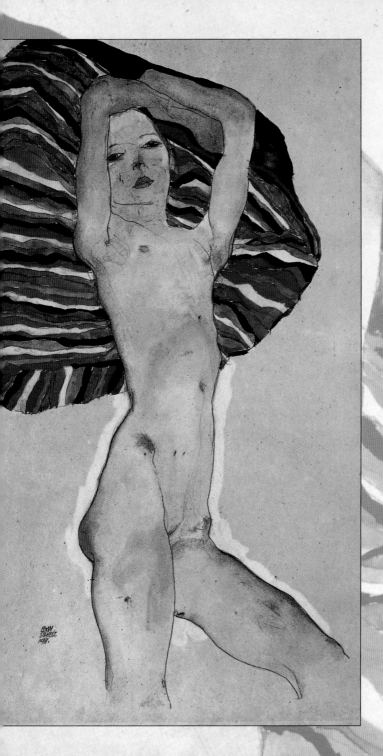

Contrary to the hygienic taboos of the upper class, for example, not to linger overly long while washing the lower body or not to allow oneself to be viewed in the nude, Schiele's drawings testify to a simple body consciousness and the matter-of-course attitude with which the lower levels of society, where love for sale pertains to earning ones daily bread, deal with sexuality.

Outraged, the Viennese public lashes out at Schiele, stating that he paints the ultimate vice and utmost depravation, while he confronts both male and female spectators with their own, hypocritical sexuality. In a letter he writes: "doing an awful lot of advertising with my prohibited drawings" and goes on to cite five notable newspapers, which refer to him. Are his nude drawings but a sales strategy that help draw attention to himself.

8. *Reclining Nude with Boots*, 1918
Charcoal on paper, 46,4 x 29,5 cm
The Metropolitan Museum of Art, New York, Bequest of Scotfield Thayer, 1982

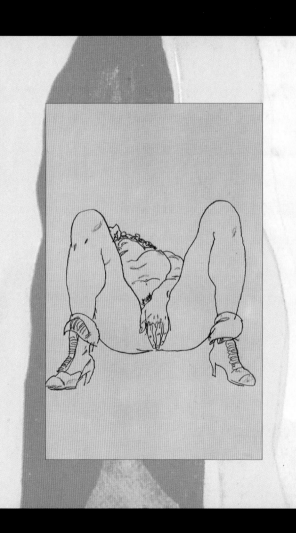

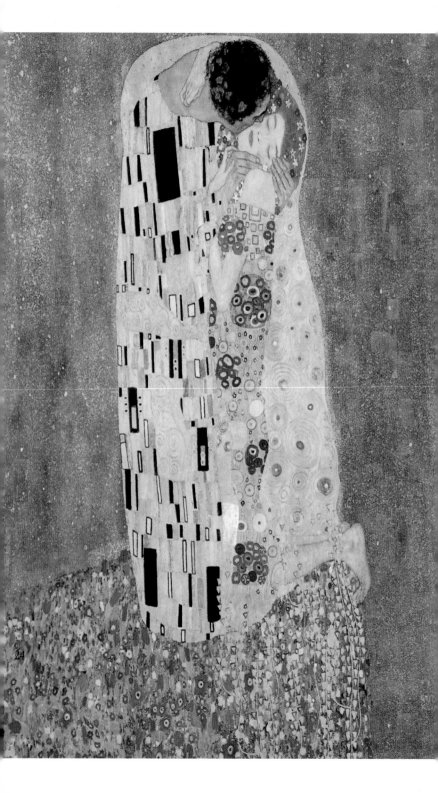

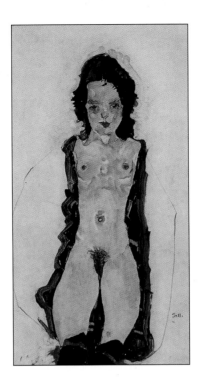

Schiele's Radicalism

Klimt's picture of woman is based on the analogy of the female body as a personification of nature. Curled tresses become stylized plant formations and the wave-like silhouette melts into a consecrated atmosphere (9). Schiele, however, breaks with the beautiful cult of organic art nouveau ornamental art. It is here, where Klimt offended the authorities in various episodes, namely in violating modesty, that Schiele finds his main objective. He radically bares persons of every decorative accessory and concentrates solely on their bodies (10).

9. Gustave Klimt, *The Kiss*, 1907–1908
Oil and gold on canvas, 180 x 180 cm
Österreichische Galerie, Belvedere, Vienna

10. *Nude with Red Garters*, 1911
Watercolor and pencil on paper, 54,6 x 36,5 cm
Private collection

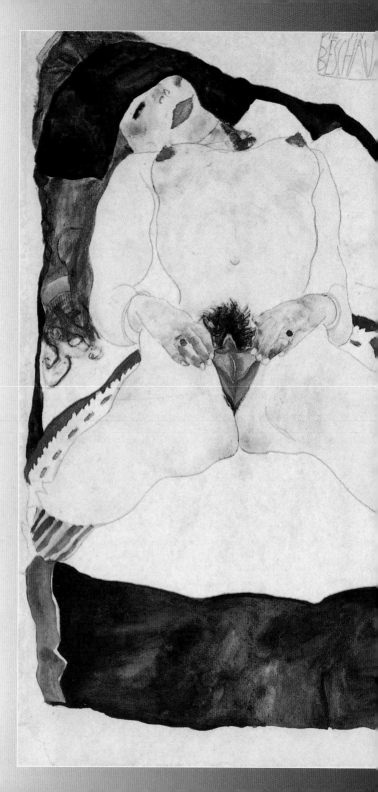

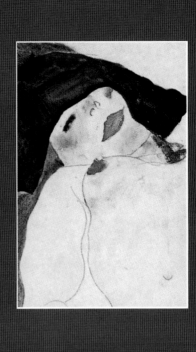

Yet, in contrast to the academic nude drawings, which mainly limit themselves to neutral coverage of the anatomy, Schiele brings the erotically-aroused body into play. He knows of the erogenous function that charms the eye and sets erotic signals with red painted lips, fleshy labia and dark moon circles under the eyes. The *One Contemplated in Dreams* opens her vulva (11).

11. *One Contemplated in Dreams*, 1911
Watercolor and pencil, 48 x 32 cm
The Metropolitan Museum of Art,
New York

Expressive Art process

Drawings serve Klimt as preliminary studies for his paintings. In contrast, Schiele signs his watercolors as finalized works of art. It is precisely the sketch-like, unfinished product that characterizes Schiele, who unfolds the art process even in his oil paintings. In contrast to the ornamental surface art in art nouveau painting, his sharp line executions and jagged aggressive style suggest the artist's subjective guiding hand.

Encounter with the Mirrored Image

The contour line captures the physical presence and becomes a sculpture-like containment within space. Thereby Schiele dispenses with every spatiotemporal speci-fication. Like a person regarding himself in a mirror, only seeing his face and body, like a lover, who within the body of his love, forgets the world around him. Schiele creates his self-portraits before a mirror, as well as some of his female nude drawings. A drawing illustrates this as *Schiele, Drawing a Nude Model Drawing in Front of a Mirror* (12). The scene is very illuminating, the duplication of frontal and rear views of the nude woman are revealed in the reflection, however, there, where the mirror is, stands the viewer. He functions as the mirror in which the model regards herself, reassuring herself of her body, and in whose gaze it moves. The intimacy between painter and model is countered in relationship to viewer and drawing.

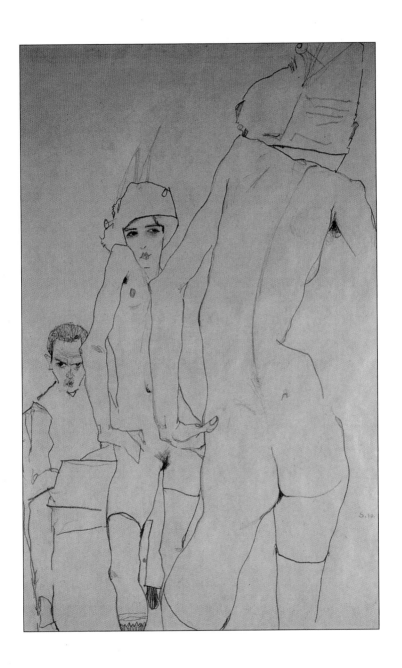

12. *Schiele, Drawing a Nude Model in Front of a Mirror*, 1910
Pencil, 55,2 x 35,3 cm
Graphische Sammlung Albertina, Vienna

First Exhibitions

In 1908, Schiele partakes in a
public exhibition in the imperial
hall of the Klosterneuburg
Monastery for the first time.
Subjects are the small-scale land-
scapes, which he had painted
out-of-doors from summer
through to the fall (13).
According to Jane Kallir, around
the end of 1908, Schiele had
painted nearly half of all the oil
paintings of his lifetime.

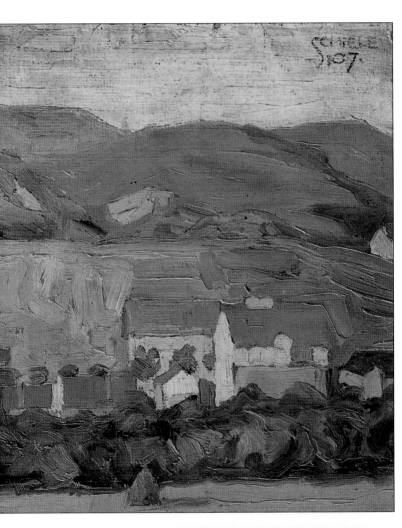

13. *Village with Mountains*
1907, Oil on paper
21,7 x 28 cm
Private collection

'New Artists'

It was only in 1909 that Schiele's artistic creativity reached the great turning point. He leaves the academy, in particular the reactionary professor Christian Griepenkerl, and establishes together with Anton Peschka, Albert Paris of Gütersloh, Anton Faistauer, Sebastian Isepp and Franz Wiegele and others the "New Art Group" (*Neukunstgruppe*). The formula of the new artists is opposition. Schiele's retreat from the subjective experience of the individual is the counter reaction to Viennese historicism and its prince of painters, Hans Makart, celebrated by the government. Schiele distances himself from their allegoric similes; the pompous veils fall. He turns Catholicism's conventional concepts of value upside down and places them into the service of sexuality. His strategy: he wants to shock. In the painting provocatively titled *The Red Communion Wafer* (14), Schiele reclines on his back in an orange shirt with his abdomen bared, his spread legs suggesting the feminine gesture of submission, while before him, gazing at the viewer, a nude strawberry-blonde holds the enormous phallus.

14. *The Red Communion Wafer*, 1911
Watercolor and pencil, 48,2 x 28,2 cm
Private collection, courtesy of Gallery St. Etienne, New York

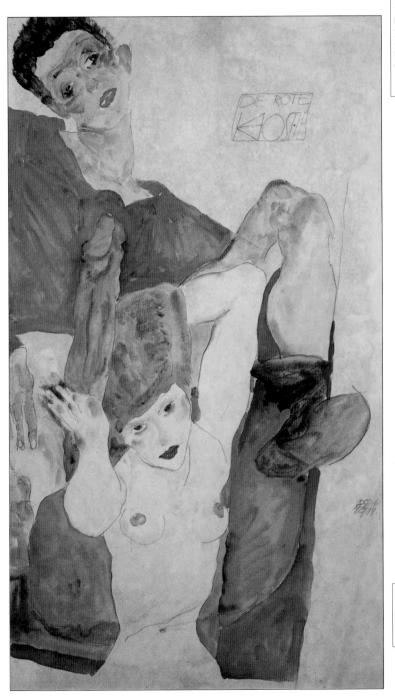

In other paintings, monks make love to nuns and expectant women who were often unwelcome and repudiated by strict Viennese society (15). "The nun prays chafed and nude before *Christ's Agony on the Cross*" (Georg Trakl, Munich, 1974). Furthermore, Schiele paints homosexual couples (16–18), transgresses taboos and provokes the fantasies of his contemporary viewers.

In turn, Schiele finds acknowledgement at the international art show in Vienna, where he is represented by four paintings next to the expressionist works of Vincent van Gogh, Edvard Munch and Oskar Kokoschka. He makes the acquaintance of Josef Hoffman, the director of the Vienna workshop. In December of 1909, the first exhibition of the "New Art Group" takes place at the Pisko's fine art dealership.

15. *Cardinal and Nun (Caress)*, 1912
Oil on canvas, 69,8 x 80,1 cm
Sammlung Rudolf Leopold, Vienna

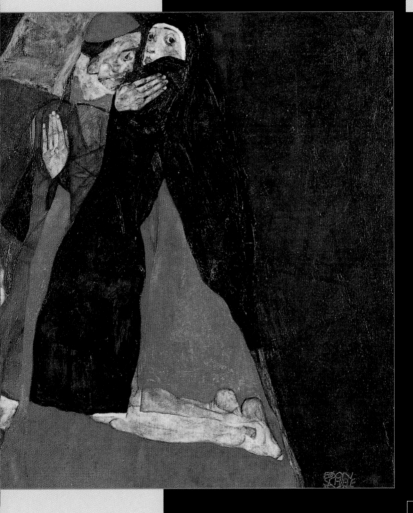

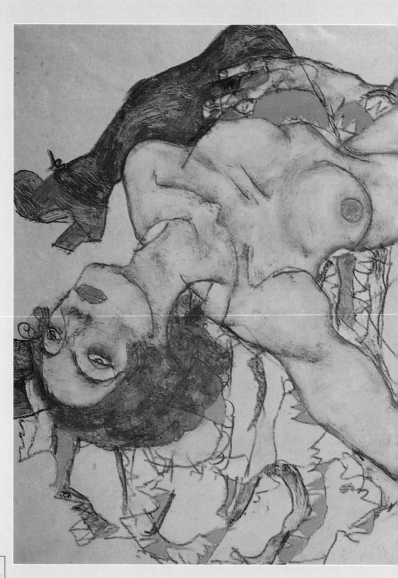

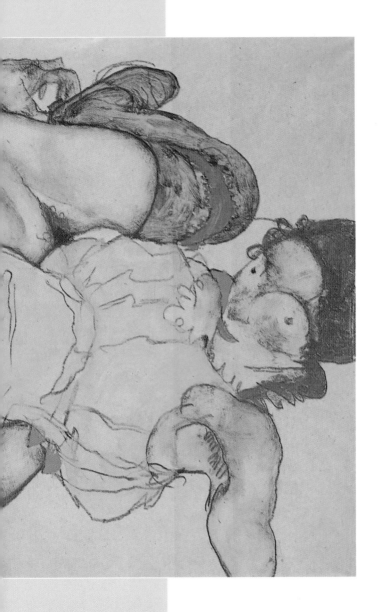

16. *Two Girls, Lying Entwined*, 1915
Gouache and pencil, 32,8 x 49,7 cm
Graphische Sammlung Albertina,
Vienna

Vienna Art Scene

In 1909, thus relatively early, Schiele makes the acquaintance of decisive personalities of the Vienna art scene, whose portraits he painted and who were to remain loyal to him for his entire life and beyond. Schiele makes the acquaintance of Arthur Roessler, writer and art critic, who becomes one of the most decisive friends and promoters of Schiele. Further figures influencing his career are the publisher Eduard Kosmack, the publisher of the magazines *The Architect* and *The Interior*, Carl Reininghausen (1857–1929), who was one of the most important Viennese collectors and the railroad official and Schiele collector Heinrich Benesch (1862–1947), who later dedicated a book to Schiele.

17. *Two Girls (Lovers)*, 1914
Gouache and pencil, 31 x 48 cm
Private collection

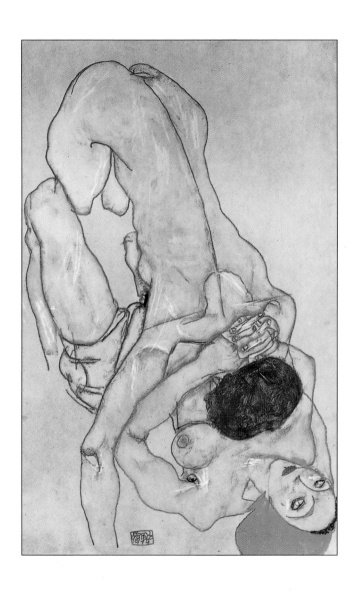

18. *Two Girls Embracing (Friends)*, 1915
Gouache, watercolor and pencil, 48 x 32,7 cm
Szépmüvészeti Múzeum, Budapest

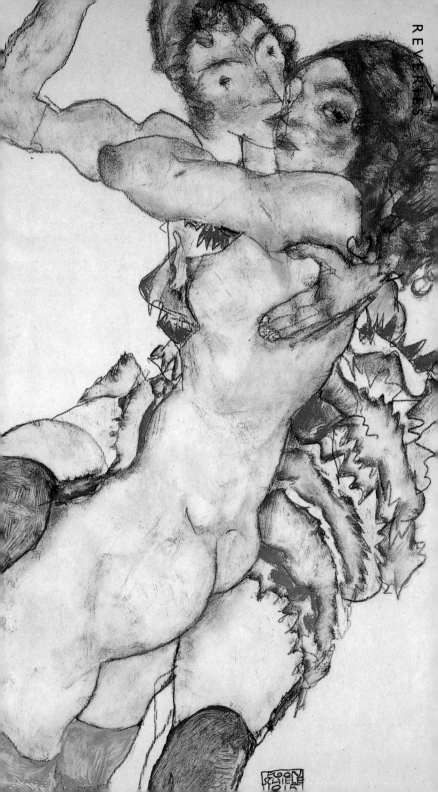

Schiele's Close Circle of Friends

Perhaps because Schiele opposes the plans of his uncle, who would like to persuade his ward to enter military service, Czihaczec withdraws his guardianship in 1910. During the same period, the incident with the mysterious lover occurs, of which, with the exception of an exchange of letters with the gynecologist Erwin von Graff, who assures Schiele, that he has admitted her to his clinic and is attending to her, nothing is known. Schiele deals with this incident in several paintings: *Birth of the Genius* and *The Dead Mother* (19). He paints a fetus, which, still in the womb of the mother, stares at the beholder. During this time, love and death studies go hand-in-hand. On the one hand, the sexual act is associated with the danger of pregnancy and the possible verdict of having to die while in the childbed, where the life-bestowing body is desecrated to death. On the other, syphilis lurks in every kiss. Is it possible to explain the subliminal, morbid trait in Schiele's world of man herewith?

19. *The Dead Mother I*, 1910
Oil and pencil on wood,
32,4 x 25,8 cm
Sammlung Rudolf Leopold, Vienna

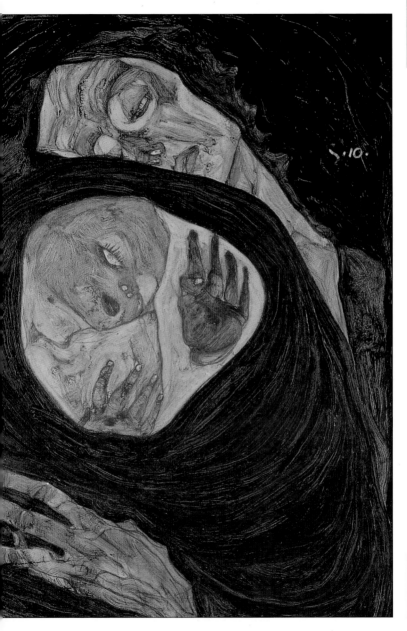

The significance of woman in turn is limited solely to her biological function of childbearing in the cult book of that time by the author Otto Weininger *Sex and Character* and comments that men of significance should only get involved with prostitutes. Whereas Freud discovers: "Upbringing denies women the intellectual occupation with sex problems, wherefore, nevertheless, they bring with them the greatest desire for knowledge; startles them with the condemnation, that desiring such knowledge is unfeminine and a sign of a sinful predisposition. Thus, they are deterred from thinking at all, knowledge is devalued for them." Inasmuch, Freud attributes alleged intellectual inferiority of so many women to sexual repression, which results in inhibition of thought.

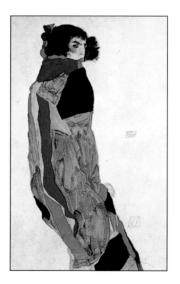

20. *The Dancer Moa*, 1911
Pencil, watercolor and
gouache on paper
47,8 x 31,5 cm
Leopold Museum
Privatstiftung, Vienna

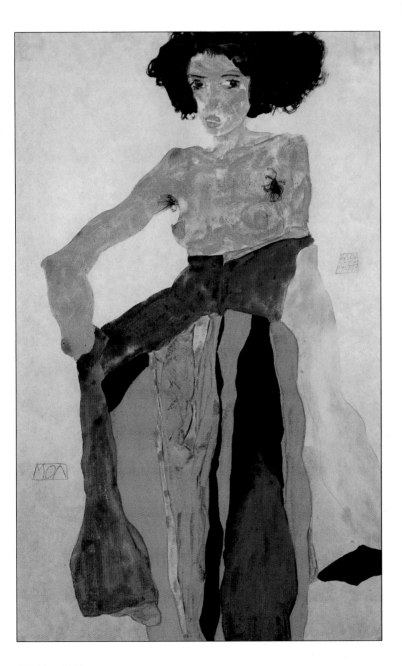

21. *Moa*, 1911
Gouache, watercolor and pencil, 48 x 31 cm
Private collection, on extended loan to the Museum of Modern Art, New York

Accompanied by his friend, the painter and mime Erwin Osen, Schiele flees to Krumau where they spend the summer with a dancer named Moa (20–22), the lover of Osen. Here Schiele also makes the acquaintance of the young baccalaureate Willy Lidl, who avows his deep love for him. Back in Vienna, Schiele shares his atelier with Max Oppenheimer (1885–1954). Day in, day out, he lives from hand to mouth. Even if young Schiele laments of financial woes, he quickly manages to get on his feet again and finds support from friends and patrons. Then in 1910, Vienna workshops, established in 1903, print three of Schiele's picture cards; at the same time he is represented with a painting at the international hunters exhibition in the context of the Klimt group.

A further exhibition at the monastery Klosterneuburg exhibits the portrait of Eduard Kosmack and that of a boy *Rainerbub*, son of the Viennese orthopedist and surgeon Max Rainer (1910). As early as 1911, the first monograph on Schiele, penned by the artist and poet Albert Paris von Gütersloh, is published. In the same year, Arthur Roessler reviews Schiele's works in the monthly periodical *Bildende Künstler*. In Vienna, Schiele partakes in the collective exhibition of the Gallery Miethke.

22. *Portrait of a Woman (The Dancer Moa)*, 1912
Pencil, 48,2 x 31,9 cm
Graphische Sammlung Albertina, Vienna

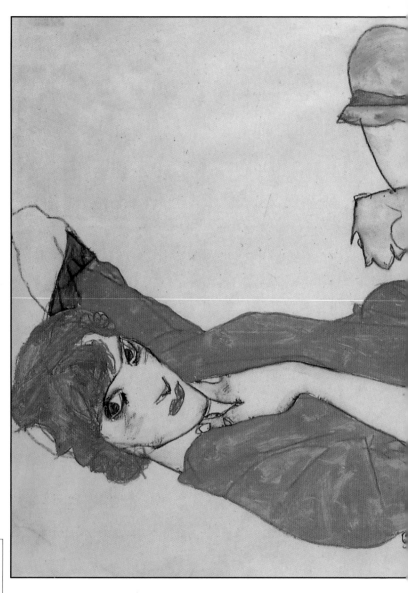

23. *Wally in Red Blouse with Raised Knees*, 1913
Gouache, watercolor and pencil, 31,8 x 48 cm
Private collection

Wally, the First Life's Companion

Once again, Schiele wants to get away.
"Vienna is full of shadows, the city is
black. I want to be alone... (in)to the
Bohemian Woods, that I need not hear
anything about myself," he writes in his
diary. Wally, (Valerie) Neuzil, former
model and lover of Klimt, who suppo-
sedly gave her to Schiele, accompanies
him. They move to his mother's home
town in Krumau on the Moldau. The
devoted Lidl had procured the atelier
with the garden. A very productive
working phase begins for Schiele.
Besides a few landscapes, he mainly
works on nude studies of himself and
Wally, his "twittering lark" (23,24). Like
the diary drawings, numerous studies
cover the erotic cohabitation of two
bodies.

24. *Woman in Black Stockings* (Valerie Neuzil), 1913
Gouache, watercolor and pencil, 32,2 x 48 cm
Private collection, courtesy of Gallery St. Etienne,
New York

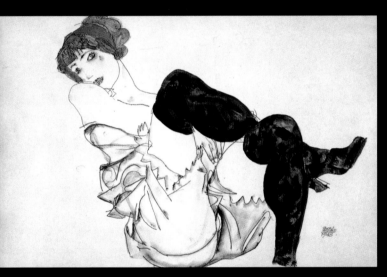

Self-Portrait as Nude Study

There are approximately 100 self-portraits with several nude studies of Schiele (25). Illustration of masculine nude studies is obligatory at the academy, psychologized self-depiction, however, apart from Richard Gerstl in 1908, is the exception. The self-portrait as nude study positions the artist not only as a person of sight, but rather in his physical being. Schiele does not act as voyeur in baring his models, rather, he brings himself into play. The nude study depicting the rigid member, masturbating, goes a step further and depicts him as the man fascinated by his own sexuality (26).

25. *Seated Male Nude* (Self-Portrait), 1910
Oil and gouache, 152,5 x 150 cm
Sammlung Rudolf Leopold, Vienna

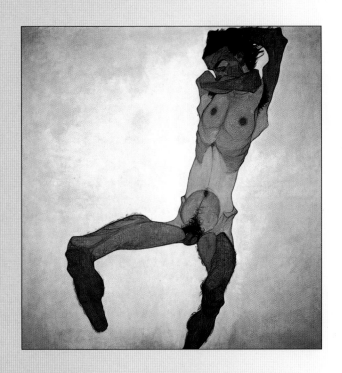

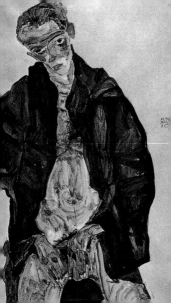

In the urge to look and show, voyeur
and exhibitionist, Freud differentiates
between a look directed at an unfamiliar
object and turning the body on show
against a part of one's own body. This
reversal in passivity accompanies the
setting a new goal: to be looked at. The
urge to look is indeed autoerotic from
the beginning; it surely has an object but
finds it in the own body. In turn, the
showing of the genitals is well known as
an apotropaic action. Accordingly, Freud
interprets "the showing of the penis and
all its surrogates" as the following
statement: "I am not afraid of you, I defy
you."

26. *Self-Portrait in Black Cloak,*
Masturbating, 1911
Gouache, watercolor and pencil
on paper, 48 x 32,1 cm
Graphische Sammlung Albertina, Vienna

Schiele, the Man of Pain

The discrepancy between Schiele's external appearance and his repulsively ugly self-portraits is astonishing (27). Gütersloh describes Schiele as "exceptionally handsome", of well-maintained appearance, "someone who never had even a day-old beard", an elegant young man, whose good manners strangely... contrasted his reputedly unpalatable manner of painting. Schiele, on the other hand, paints himself with a long high forehead, wide opened eyes deep in their sockets and tortured expression, an emaciated body, which he sometimes mutilates up to its trunk, with spider-like limbs. The bony hands tell of death at work. His body reflects the sallow colors of decay. In many places, he paints himself with a skull-like face. Schiele admits in a verse: "everything is living dead". Just as Kokoschka maintains, Schiele soliloquizes with death, his counterpart. "And surrounded by the flattery of decay, he lowers his infected lids" (Georg Trakl, Munich, 1974).

27. *The Poet* (Self-Portrait), 1911
Oil on canvas, 80,1 x 79,7 cm
Leopold Museum, Privatstiftung, Vienna

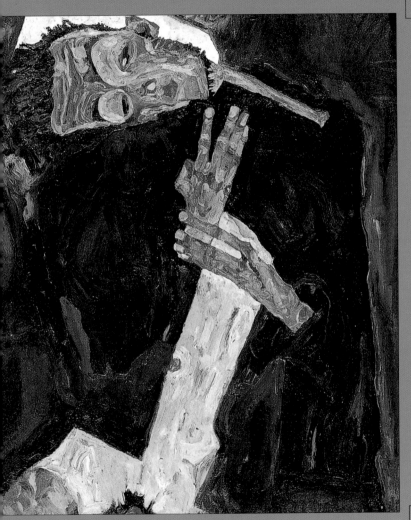

At the same time, Schiele perceives himself as a man of pain: "That I am true I only say, because I … sacrifice myself and must live a martyr-like existence." If contemporary art banished religious themes from its field of vision, the artist now incarnates these himself.

In a letter to Roessler the Christ-likeness becomes clearer still: "I sacrificed for others, for those on whom I took pity, those who were far away or did not see me, the seer." His fate as an outsider leads to the ideal of the artist as world redeemer (28). In the program of the New Artists he explains: "Fellow men feel their results, today in exhibitions. The exhibition is indispensable today … the great experience in the existence of the artist's individuality." For him, however, this no longer concerns telling illustration, rather, representation of his soul's inner life. The nude study is a revealing study. Thereby, the work in its expressive self-staging becomes a performative study of his life.

28. *Nude Self-Portrait*, 1910
Watercolor, gouache and black crayon with white highlighting, 44,9 x 31,3 cm
Leopold Museum, Privatstiftung, Vienna

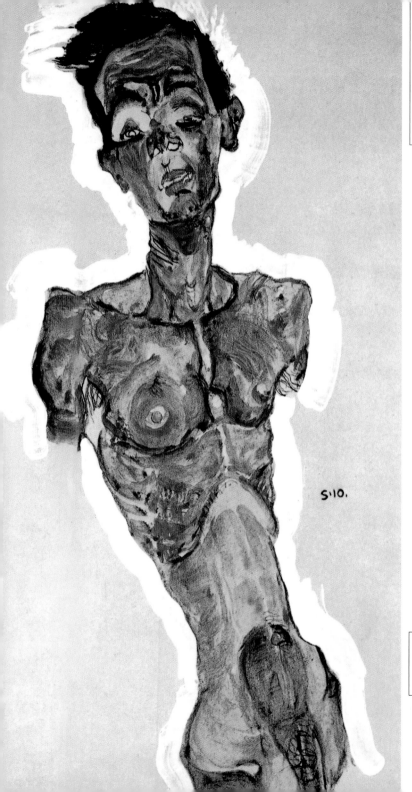

S·10.

"That I am
true
I only say
because I…
sacrifice myself
and must live a
martyr-like
existence"

29. *Standing Woman in Red*, 1913
Gouache, watercolor and pencil
48,3 x 29,2 cm
Private collection, courtesy of Gallery St. Etienne,
New York

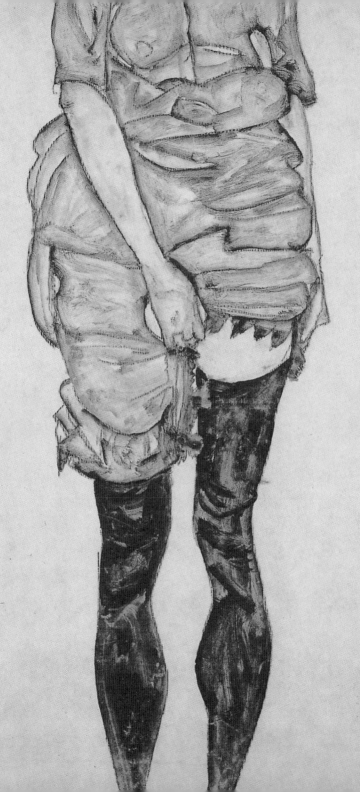

Fascination with Death

Viennese of the turn of the century live with a longing for death and romanticize the "beautiful corpse". "How ill everything coming into being does seem to be," writes Trakl, who in 1914 finds death at the front. Schiele shares with Osen, who has himself locked away in a Steinhof insane asylum where he might study the mimic of patients there, the interest for pathologic pictures of disease. In the clinic of the gynecologist Erwin von Graf, he studies and draws sick and pregnant women (30) and pictures of new and stillborn infants (31).

30. *Red Nude, Pregnant*, 1910
Watercolor and charcoal, 44,5 x 31 cm
Private collection

31. *Newborn Baby*, 1910
Watercolor and charcoal, 46 x 32 cm
Private collection, courtesy of Gallery St. Etienne, New York

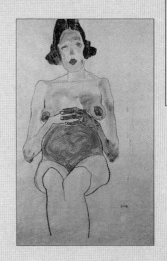

Schiele is "fascinated by the devastation of foul suffering, to which these, in principal innocents, are exposed. Astonished, he saw unusual changes in the skin, in whose sagging vessels thin, watery blood and tainted fluids trickled sluggishly, he marveled also at light-sensitive green eyes behind red lids, the slimy mouths – and the soul in these unsound vessels", reports Roesseler.

Therein he resembles Oskar Kokoschka, called the "soul slasher" and of whom it was said that "…painting hand and head, he lay bare in ghostly manner the spiritual skeleton of her whom he portrayed". To the color lithograph of his drama, *Murder Hope of Women*, he comments: "The man is bloody red, the color of life, but he lies dead in the lap of a woman, who is white, the color of death." Man and woman form the dance of life and death.

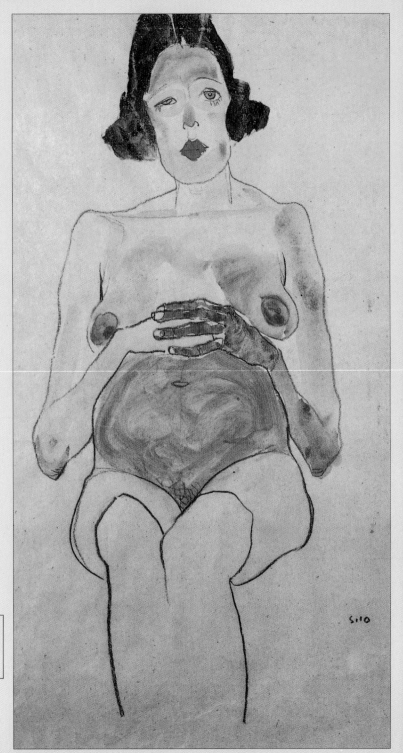

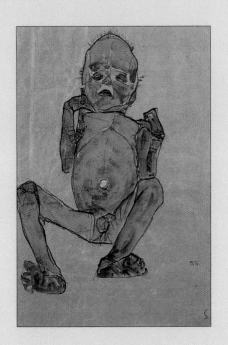

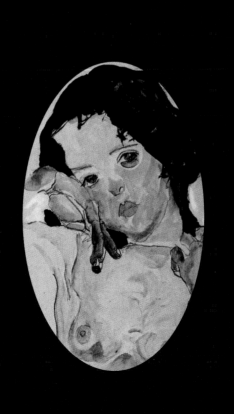

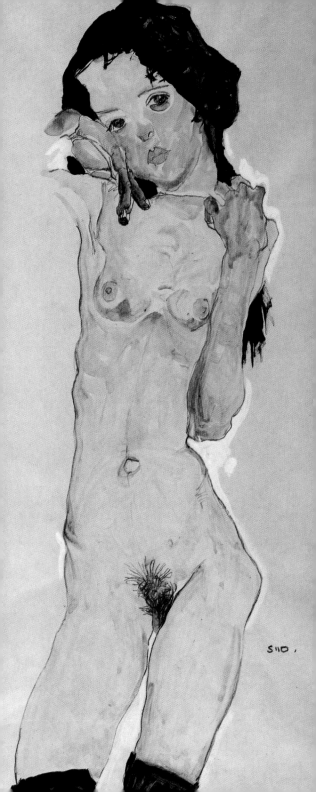

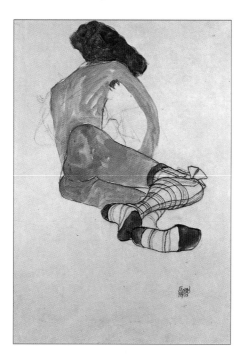

33. *Seated Female Nude with Blue Garter,*
Back View, 1910
Gouache, watercolor and charcoal
45 x 31,5 cm
Private collection

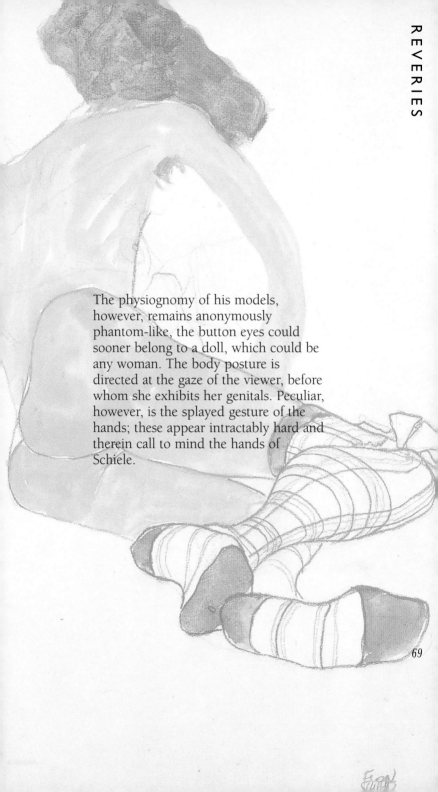

The physiognomy of his models, however, remains anonymously phantom-like, the button eyes could sooner belong to a doll, which could be any woman. The body posture is directed at the gaze of the viewer, before whom she exhibits her genitals. Peculiar, however, is the splayed gesture of the hands; these appear intractably hard and therein call to mind the hands of Schiele.

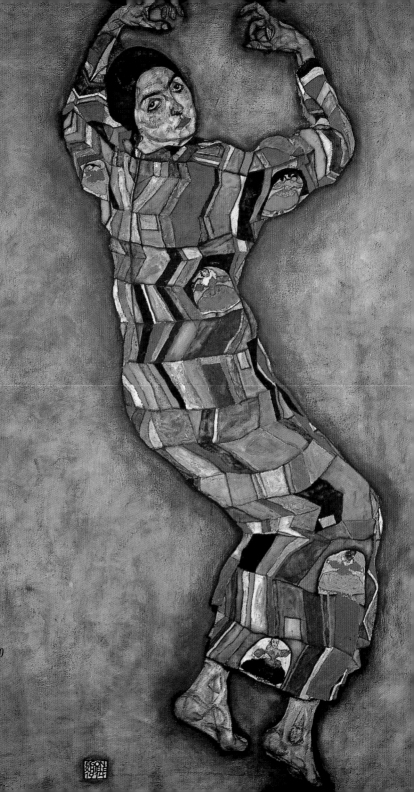

70

Body Perspectives

Schiele ignores light and shadow effects, which model the body, dispenses with shadow strokes and divests the character of all spatial containment. In his atelier, he often works on a ladder, from where he captures his models from a bird's eye view perspective in an extreme visual angle of under and oversight. This calls to mind one of his verses: "An intimate bird sits in a leafy tree, he is dull colored, hardly moves and does not sing; his eyes reflect a thousand greens." He isolates his creatures in his view, sets them into a world without time or place. Bodies form space.

Exemplary for spatial lack of orientation of his characters is the commissioned artwork *Friederike Maria Beer*, a fashion conscious daughter of a cabaret proprietor, who actively followed Viennese art events (34). On Schiele's suggestion, she allows her full body likeness to be painted on the ceiling. It shows her in a variegated dress with mime-like bearing, her body strangely floating, free of all gravitational pull, raised arms with the indefinable hand gesture call to mind Schiele's self-portraits once again.

71

34. *Portrait of Friederike Maria Beer*, 1914
Oil on canvas, 190 x 120,5 cm
Private collection

Vampire-like Trait of the Sex

Ulrich Brendel writes in the periodical *Die Aktion* Schiele is said to capture "the vampire-like trait of the sex". His models lament: "It is no pleasure; he always sees only the 'one' thing." At the same time, Freud discovers the fear of castration mechanism: "the sight of Medusa's head, that is to say, that of the feminine genitalia, causes one to become rigid with fright, transforms the beholder into stone. ... Because to become rigid signifies the erection." A girl, her face remaining anonymously sketch-like, reclines backwards; her uplifted skirt is a work of pleats out of which her genitals peek becoming an inner eye slit. Again and ever again, Schiele discovers and sees, shows and offers the most intimate, forbidden part to the viewer. He carefully watercolors it into a full fruit, a calyx of orange color (35,36).

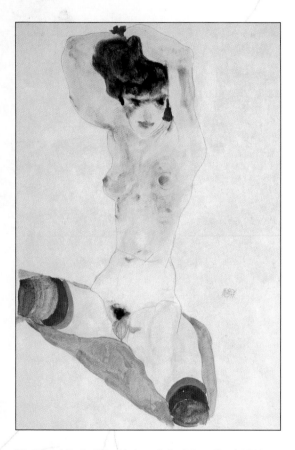

35. *Seated Nude Girl with Arms Raised Over Head*, 1911
Watercolor and pencil, 48,2 x 31,4 cm
Private collection

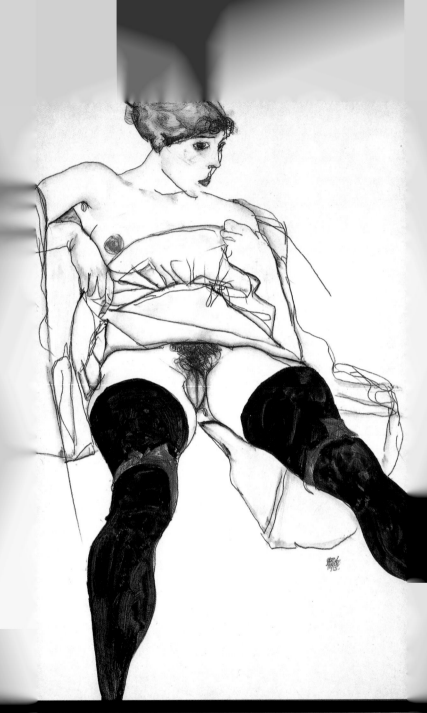

6. *Woman with Black Stockings*, 1913
Gouache, watercolor and pencil, 48,3 x 31,8 cm
Private collection, courtesy of Gallery St. Etienne, New York

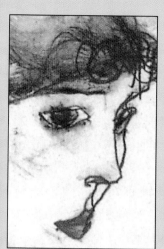

Disgust and Allure

Schiele scarcely models the bodies he paints, only a few colored splotches animate the white paper surface on which the body seems to lie confined by a few lines. Schiele's patron, Carl Reininghausen, whom Schiele instructs in drawing and painting, complains that he "paints so casually that the composition is no longer recognizable in places due to the splotches". The marks on the body executed with the use of a lave cause astonishment; often in contrasting colors of green and red, they create aggressive tension. In contrast to the general impression of the shape, the splotches point to the closer view, this in intimacy with everything else exposes the condition of the skin. Schiele's models do not possess unblemished white, alabaster bodies, rather, he gets under their skin (37,38). "The body becomes a wound" (Werner Hofmann, Munich, 1981). Schiele turns the fleshy inner part of the vagina inside out.

37. *Standing Nude, Back View*, 1910
 Gouache, watercolor and pencil
 with white highlighting, 56 x 33,1 cm
 Private collection

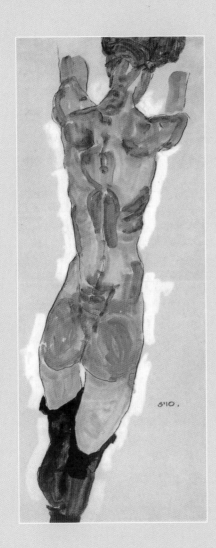

As to the aesthetics of the color splotches, which, like the famous splotched paintings by Rorschach, render the viewer a projection surface, Hugo von Hofmannstal reminds that "art is magical writing, which uses colored splotches instead of words to portray an internal vision of the world, a puzzling one, without being…" Contemporaries, however, characterize Schiele's art as "manically demonic". "Some of his pictures are the materializations of obscured consciousness of apparitions grown bright." His friend Roessler in turn stresses that his face is the synthesis of inner human existence. Doubtless, the nude studies reflect the inner world of the soul's condition imposed onto the model by the artist. "I am everything at once, but never shall I do everything all at once," declared Schiele, who multiplicates through psychological role-playing and fuses into the picture of his models. Thereby, all artistic means aim at capturing the psychological experience of Schiele himself.

38. *Crouching Nude in Shoes and Dark Stockings, Back View*, 1912
Gouache, watercolor and pencil on paper, 48,9 x 32 cm
The Metropolitan Museum of Art, New York, Bequest of Scotfield Thayer, 1982

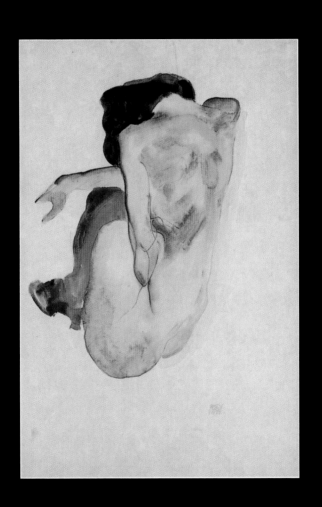

The Age of the Pornographic Industry

In the year 1850, with the invention of photography, in particular the daguerreotype, pornographic photos also come into fashion (39). On the one hand, the photos served as a model for artists, also for Schiele, who made quite a few photos of his models. On the other hand, they were collector items for erotomanics. Mainly, however, they were used as presentation cards at bordellos by means of which the visitor could compile his "menu". The production of erotic pictures was not prohibited, advertising was. In so doing, the models as well as the photographer risked going to jail. The first conviction follows in 1851. When 4,000 obscene prints and four large albums of "nude women" are discovered in the possession of the French photographer Joseph-Antoine Belloc, he receives a minor sentence of three months detention. The models were largely prostitutes, easy women, but also working women in dire financial straits and gutter children picked up from the streets.

To satisfy voyeuristic desire, the Munich publisher Guilleminot Recknagel had a stock of 4,000 photos of ten to thirty-year-old models in stock. Starting in approximately 1870, erotic postcards came into circulation. Thematic scenes of Greek and Roman mythology, heroic or Christian martyr scenes with the naked Magdalene, crucifixion of female characters and nude Greeks were to give these photos a certain value. In provisional theaters, such adjustment of pictures is very popular. Famous collectors were the Marquis of Byros in Vienna and in Munich Doctor Kraft Ebbing. Particularly the Baron von Meyer loved the "sweet girls" from Vienna.

Schiele surely profited from the high sales of pornographic photos in direct relation to lustful consumption. Yet, his erotic drawings testify to a personal question, which in turn is embodied in the epoch of decadence, namely the dialectics of carnal desire and death instinct.

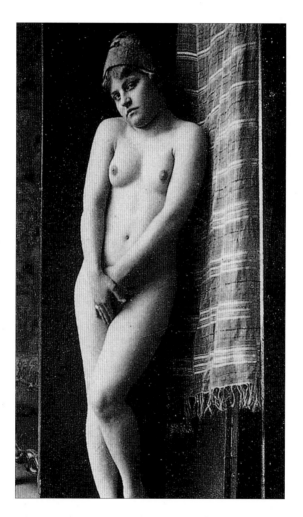

39. *The Sweet Maid*, 1914
Erotic photography, Private collection

Schiele's Arrest

In August 1911, Schiele feels impelled to relocate to Neulengbach near Vienna in Lower Austria with Wally. His retreat to the country was naïve and out of touch with reality. Inevitably, he would offend the conservative population with his unorthodox life style. Predictably, living in sin with the still under-age Wally would rile the population of the provincial town against Schiele.

For the village youth, however, Schiele's studio was a haven of well being. Gütersloh describes the free-spirited atmosphere: "well, they slept, recuperated from parental thrashings, lazily lolled about, something they were not permitted to do at home…"; until April 13, 1912, when a catastrophic incident came about. The father of a thirteen-year-old girl, who had run away from home and found refuge in Schiele's home, reported him for kidnapping. The charge is withdrawn, but Schiele is arrested and charged with endangering public morality and circulation of "indecent" drawings.

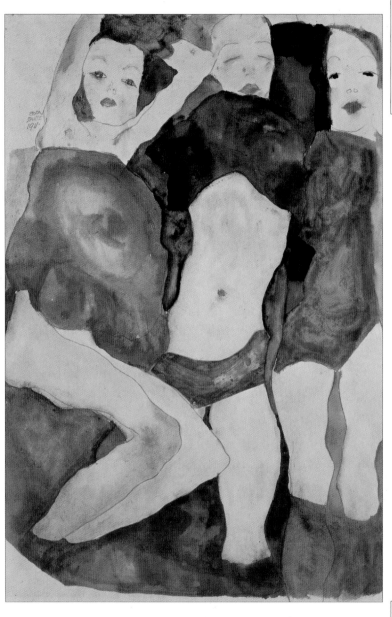

40. *Three Girls*, 1911
Watercolor and pencil, 48 x 31,5 cm
Private collection

Schiele's defense by Heinrich Benesch, however, is naïve, when he writes: "...Schiele's carelessness is responsible for the incident. Whole swarms of little boys and girls came into Schiele's studio to frolic. There they saw the nude study of a young girl." For the sake of his art, Schiele forgets all modesty, lifts the skirts of the sleeping children, surprises two girls embracing one another (40–42). Exposure of his own private sphere as well as that of others becomes a confession-like, artistic expression of his own truthfulness. The private sphere and public domain become inter-changeable.

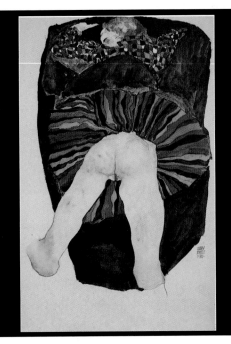

41. *Reclining Semi-Nude*, 1911
Pencil, watercolor and gouache on paper, 47,9 x 31,4 cm
Private collection

42. *Two Girls on Fringed Blanket*, 1911
Gouache, watercolor, ink and pencil, 56 x 36,6 cm
Private collection, courtesy of Gallery St. Etienne, New York

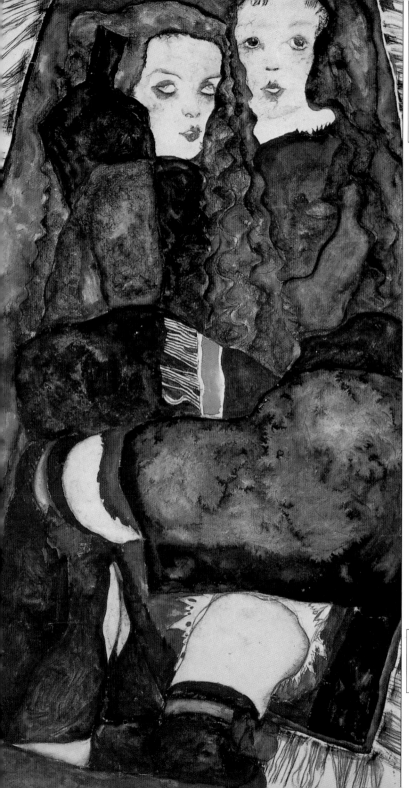

Schiele's influential collector Carl Reininghausen procures an attorney in Vienna for him, but at the same time dispenses with the "cordial you" (informal) between them. In St. Pölten, Schiele spends 24 days in custody. He pleads: "To inhibit an artist is a crime. It is called murder of life coming into being" (44). The prison stay validates him, the artist, in his role as an outsider. "The one orange was the only light." Several self-portraits of Schiele as prisoner testify to this time. Solemnly the judge will burn one of the indecent drawings in the courtroom. There that Schiele expresses: "I do not feel chastised, but cleansed."

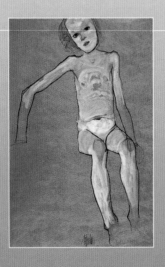

43. *Seated Nude Girl*, 1910
Gouache and black crayon with white highlighting, 44,8 x 29,9 cm
Graphische Sammlung Albertina, Vienna

44. *Hindering the Artist is a Crime, it is Murdering Life in Bud!*, 1912
Watercolor and pencil, 48,6 x 31,8 cm
Graphische Sammlung Albertina, Vienna

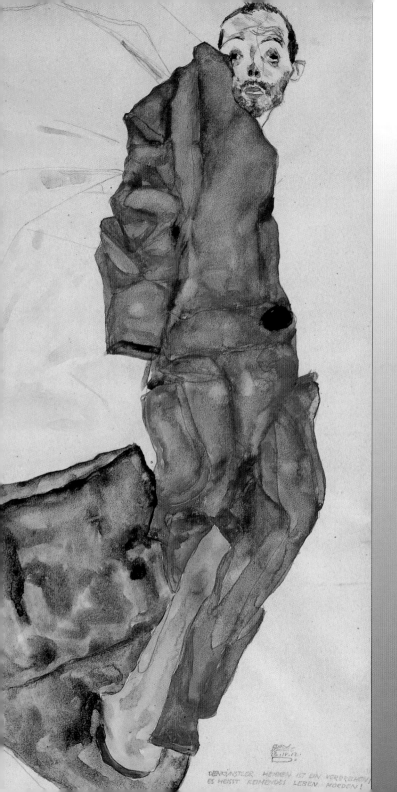

International Artist

In Munich the art dealer Golz exhibits Schiele's works. In this critical year of 1912, the New Art Group, together with the artists union displays *Der Blaue Reiter* (the Blue Rider) in Budapest, Munich and Essen. In November 1912, Schiele returns to Vienna and moves into an atelier in the Hiertzinger Hauptstrasse. Klimt acquaints him with the collector August Lederer, whose son Erich becomes his pupil. Franz Pfemfert publishes poems and drawings by Schiele in the Berlin periodical *Die Aktion*. Three of Schiele's works can be seen in the international special alliance exhibition in Cologne. The lithograph *Male Nude Study* appears in the *Sema-Mappe* (portfolio) of the Delphin Publishing House in Munich. In 1913, Schiele becomes a member of the *Bund Österreichischer Künstler* (federation of Austrian artists), of which Gustav Klimt is president. In the same year, he goes to Munich, where he partakes in the collective exhibition of the Galerie Golz.

On July 28, 1914, war is officially declared between the Austro-Hungarian Empire and Serbia. Schiele comments: "We live in the most violent time the world has ever seen… Hundreds of thousands of people perish miserably – everyone must bear his fate either living or dying – we have become hard and fearless. That which was before 1914 belongs to another world."

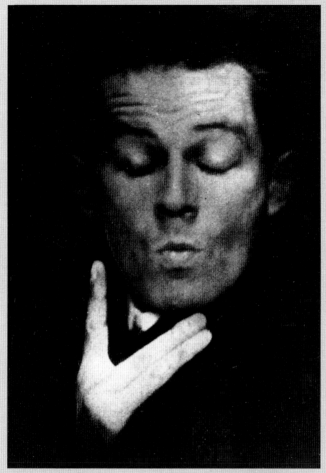

45. *Photograph of Anton Josef Trcka*, 1914
Egon Schiele
Graphische Sammlung Albertina, Vienna

46. *Standing Girl in Blue Dress and
Green Stockings, Back View*, 1913
Watercolor and pencil, 47 x 31 cm
Private collection

Schiele continues with his work, he is now an internationally recognized artist, who partakes in exhibitions in Rome, Brussels and Paris. Anton Josef Trcka (1893–1940) photographs Schiele in extravagant pantomime poses, in a strong gesticulating blind language (45). In the Berlin periodical *Die Aktion* he writes: "We are above all people of the times, in other words, such who have at the very least found the way into our present time."

In 1915, the Vienna Galerie Arnot dedicates an exclusive exhibition of sixteen paintings, watercolors and drawings to Schiele, among them, Schiele's *Self-Portrait as St. Sebastian* (47). With this religiously engaged role model, he stands in the tradition of Oskar Kokoschka, Rainer Maria Rilke und Georg Trakl, who see themselves as martyrs tormented by society, yet at the same time, Schiele holds the reins of his career adroitly in hand.

Next page:
48. *Coitus*, 1915
Gouache and pencil, 31,6 x 49,8 cm
Leopold Museum, Privatstiftung, Vienna

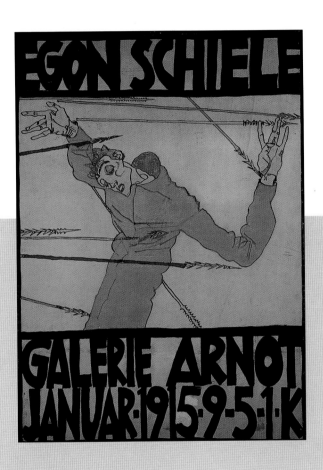

47. *Self-Portrait as St. Sebastian* (Poster), 1914–1915
Gouache, black crayon and ink on cardboard, 67 x 50 cm
Historisches Museum der Stadt Wien, Vienna

"We are above all people
of the times, in other
words, such who have

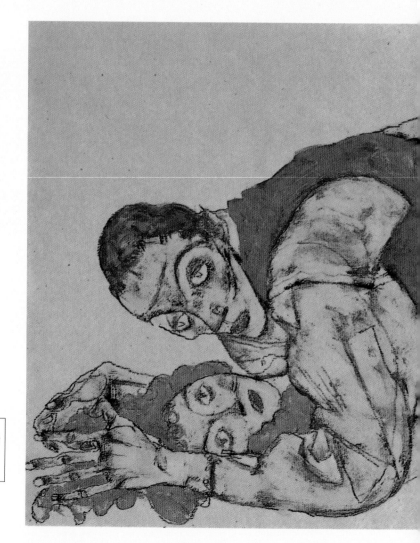

at the very least
found the way into
our present time"

Schiele's Skillful Social Maneuver

Schiele's beloved sister Gerti marries his fellow artist, Anton Peschka, whose young son often spends time with his uncle. Across from Schiele's atelier lived his landlords, the middle-class Harms family with their two young daughters (49–51). Schiele, disguised as an Apache, allows them to see him at the window. Later he sends Wally with an invitation to the cinema and the assurance that she too would accompany them. The two sisters model for Schiele and, in their vanity, compete for the favors of the young artist. Coldheartedly he informs Wally that he will marry Edith (52), the socially more advantageous match for him, whereupon she joins the Red Cross as a nurse and goes to the front where she will succumb to scarlet fever in 1917. In the allegorical painting *Death and the Maiden*, Schiele himself – he settles to terms with the separation from Wally (53).

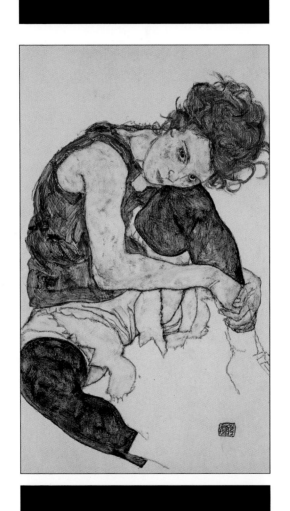

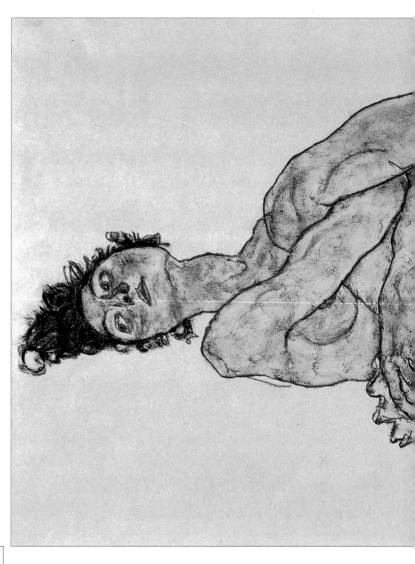

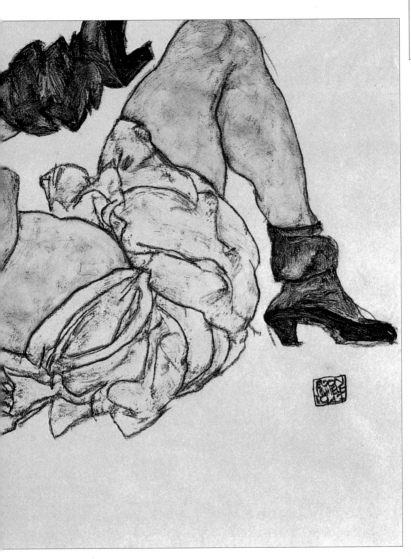

50. *Reclining Female Nude*, 1917
Gouache, watercolor and charcoal, 29,7 x 46,3 cm
Moravská Galéri, Brno

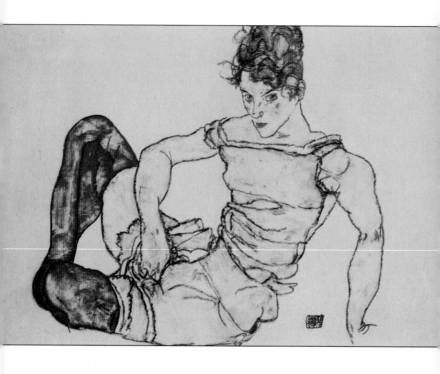

51. *Seated Woman in Violet Stockings*, 1917
Gouache and black crayon, 29,6 x 44,2 cm
Private collection

52. *Portrait of the Artist's Wife Seated,*
Holding Her Right Leg, 1917
Gouache and black crayon, 46,3 x 29,2 cm
The Pierpont Morgan Library, New York

Next page:
53. *Death and the Maiden*, 1915–1916
Oil on canvas, 150 x 180 cm
Österreichische Galerie, Belvedere, Vienna

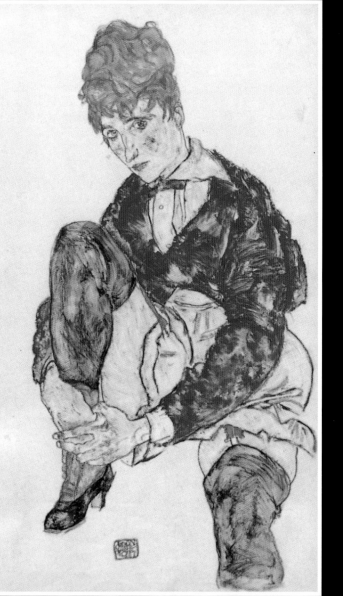

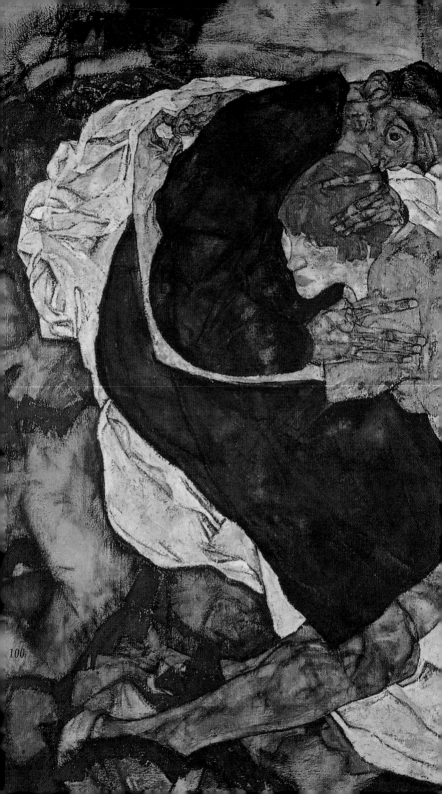

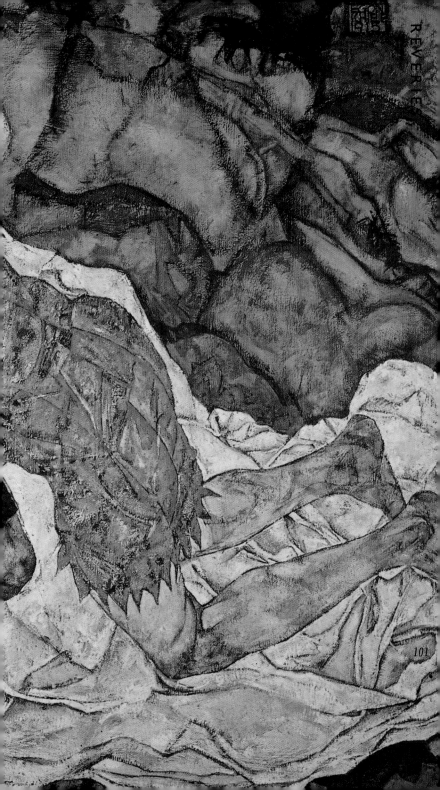

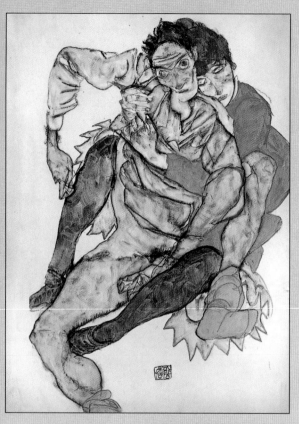

The Bourgeois Schiele

On June 17, 1915, five days after his twenty-fifth birthday, Schiele marries Edith Harms. Four days later, he is inducted into military service in Bohemia. In 1916, he is held captive in the Russian prisoner of war camp located in Mühlung near Wieselburg. *Die Aktion* publishes two xylographs (55). One year later, Schiele returns to Vienna to work in the army museum.

In the beginning, his wife is his exclusive model. However, as she grows plumper, Schiele once again begins to look for models elsewhere (56,57). In 1918, 117 sessions with other models are recorded in his notebook. The Vienna book dealer Richard Lanyi publishes a portfolio with twelve collotypes of Egon Schiele's drawings. In December, Schiele works for the periodical *The Dawn*. In a letter of March 2, 1917 Schiele writes to his brother-in-law: "Since the bloody terror of world war befell us, some will probably have become aware that art is more than just a matter of middle-class luxury."

54. *Seated Couple (Egon and Edith Schiele)*, 1915
Pencil and gouache on paper, 52,5 x 41,2 cm
Graphische Sammlung Albertina, Vienna

55. Cover of the Egon Schiele issue of *Die Aktion*, 1916
Graphische Sammlung Albertina, Vienna

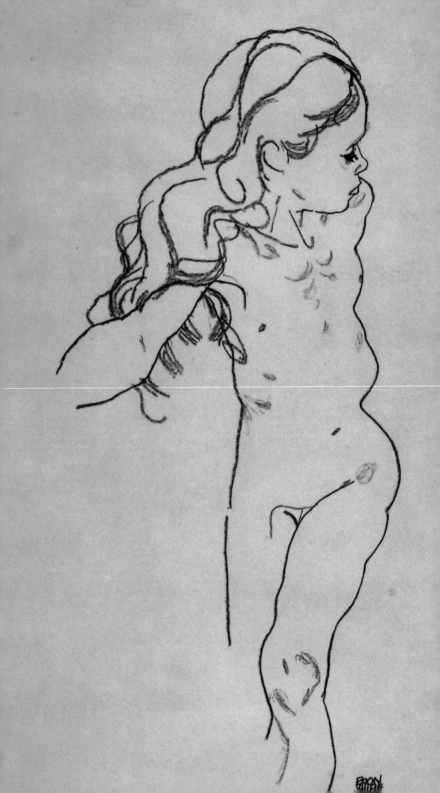

"Since the bloody terror of world war befell us, some will probably have become aware that art is more than just a matter of middle-class luxury"

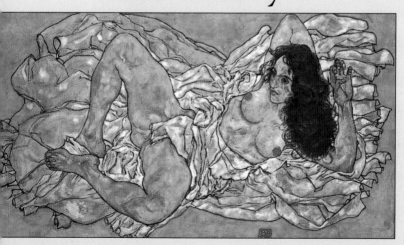

56. *Standing Nude Girl*, 1918
Black crayon on paper, 45,7 x 29,5 cm
Private collection, New York

57. *Reclining Woman*, 1917
Oil on canvas, 95,5 x 171 cm
Sammlung Rudolf Leopold, Vienna

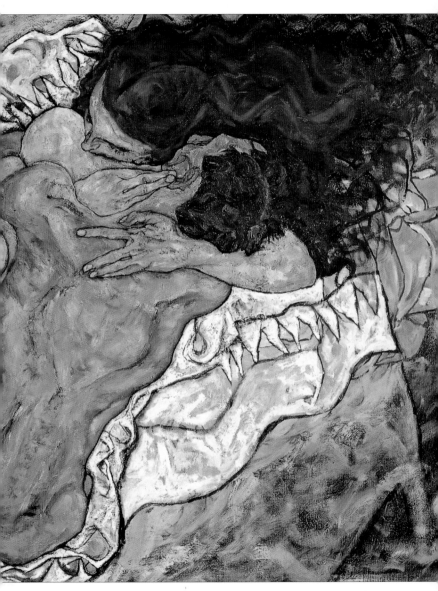

58. *Embrace (Lovers II)*, 1917
Oil on canvas, 100 x 170,2 cm
Österreichische Galerie, Belvedere, Vienna

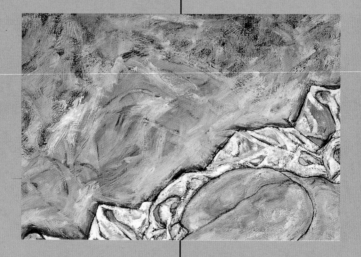

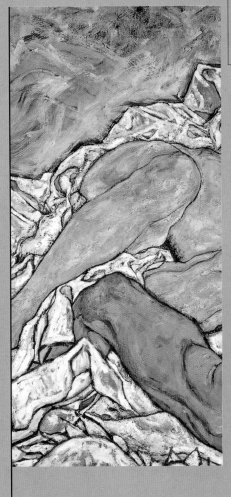

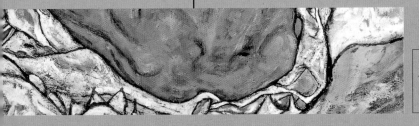

Time has caught up with its art

Marriage and perhaps the war also change Schiele's style. It becomes softer and more harmonious. The subject of motherhood occupies him. One of the most important works of this time is the erotic *Embrace*: On a sea of white pleats, Edith and Egon lie closely entwined with one another, two bodies in one (58). However, in another oil painting, *The Family*, he paints himself and his wife with their child in peculiar gloomy colors (59).

59. *The Family* (Squatting Couple)
1918, Oil on canvas
152,5 x 162,5 cm
Österreichische Galerie
Belvedere, Vienna

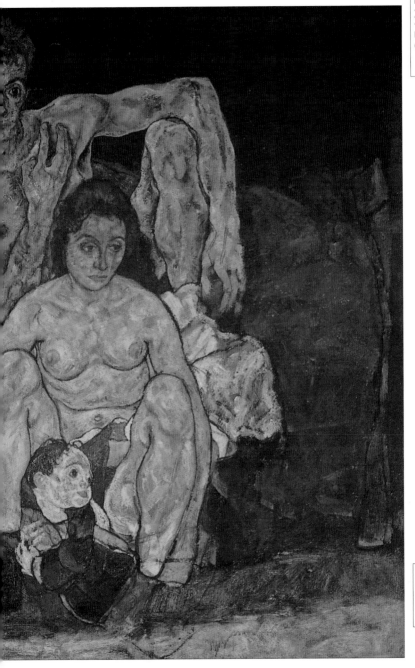

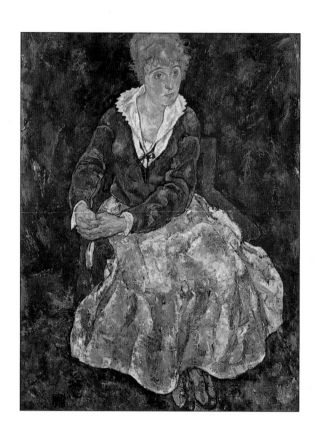

Schiele, a Celebrated Artist

After the sudden death of Klimt and the exile of Kokoschka, Schiele is the celebrated artist in Vienna. Very successfully, he partakes in the 49th Vienna Secession of 1918 with 19 large paintings and 24 drawings. Franz Martin Haberditzl purchases the *Portrait of the Artist's Wife, Seated* for the Moderne Galerie. It is the first acquisition of a painting while the artist is yet alive. However, Schiele must paint over the plaid skirt, as the museum's director finds it too indecent (60). Schiele can now afford a larger atelier, the old one is to become an art school. Already in 1917, Schiele had a plan for an art center, where the various disciplines of literature, music and visual art coexist. The best-known founding members are Schönberg, Klimt, and the architect Hofmann.

Death, however, prevents these plans. On October 31, three days after the death of his six-month pregnant wife, Schiele also dies from the Spanish flu.

Three days thereafter, on November 3, 1918, the Austro-Hungarian Empire capitulates.

60. *Portrait of the Artist's Wife, Seated*, 1918
Oil on canvas, 139,5 x 109,2 cm
Österreichische Galerie, Belvedere, Vienna

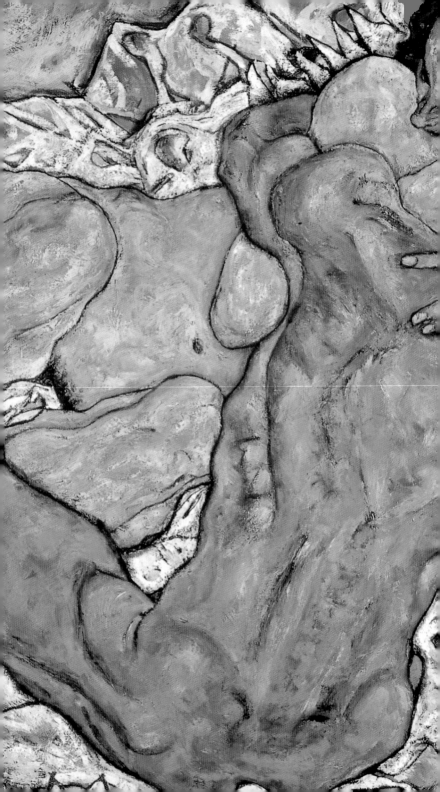

Bibliography
List of illustrations

Bibliography

Heinrich Benesch, *Mein Weg mit Egon Schiele*, (ed.) Eva Benesch, New York, 1965.

Jean Clair, 'Une modernité sceptique', in *Vienne 1880–1938, L'Apocalypse Joyeuse*, exhibition catalogue, (ed.) Jean Clair, Centre Georges Pompidou, Paris, 1986.

Alessandra Comini, *Egon Schiele's Portraits*, Berkeley/Los Angeles/London, 1974.

Alessandra Comini, *Egon Schiele*, New York, 1976.

Arthur C. Danto, 'Vienna 1900', in *Reiz und Reflexion*, Munich, 1994.

Werner Hofmann, 'Egon Schiele', in *Experiment Weltuntergang, Wien um 1900*, exhibition catalogue, Hamburger Kunsthalle, Munich, 1981.

Jane Kallir, *Egon Schiele, Complete Works*, New York, 1990.

Erwin Mitsch, *Egon Schiele*, (7th edition) Munich, 1991.

Pia Müller-Tamm (ed.) *Egon Schiele, Inszenierung und Identität*, Cologne, 1995.

Christian M. Nebehay, *Egon Schiele 1890–1918, Leben, Briefe, Gedichte,* Salzburg/Vienna, 1979.

Christian M. Nebehay, *Egon Schiele – Leben und Werk*, Salzburg/Vienna, 1980.

Arthur Roessler, *Erinnerungen an Egon Schiele, Marginalien zur Geschichte des Menschentums eines Künstlers*, Vienna, 1922.

Klaus Albrecht Schröder, *Egon Schiele, Eros und Passion*, Munich/New York, 1998.

Sigmund Freud, '*Das Medusenhaupt*', in *Gesammelte Schriften*, Alexander Mitscherlich *et al.*, Vol. XVII, Frankfurt/Main, 1970.

Georg Trakl, 'Gesang des Abgeschiedenen', in *Das dichterische Werk*, Munich, 1974.

Otto Weininger, *Geschlecht und Charakter*, Vienna, 1903

Captions